Best Of Fuck Off

Hilarious Vulgar Adult Swear Word

Coloring Book For Release Stress

Violin Villa

Copyright © 2017 by Vilolin Villa

All rights reserved worldwide. No part of this publication may be reproduced or distributed in any form or by any means, mechanical, electronic or stored in a retrieval or database system, without written permission from the copyright holder.

Happy Coloring!

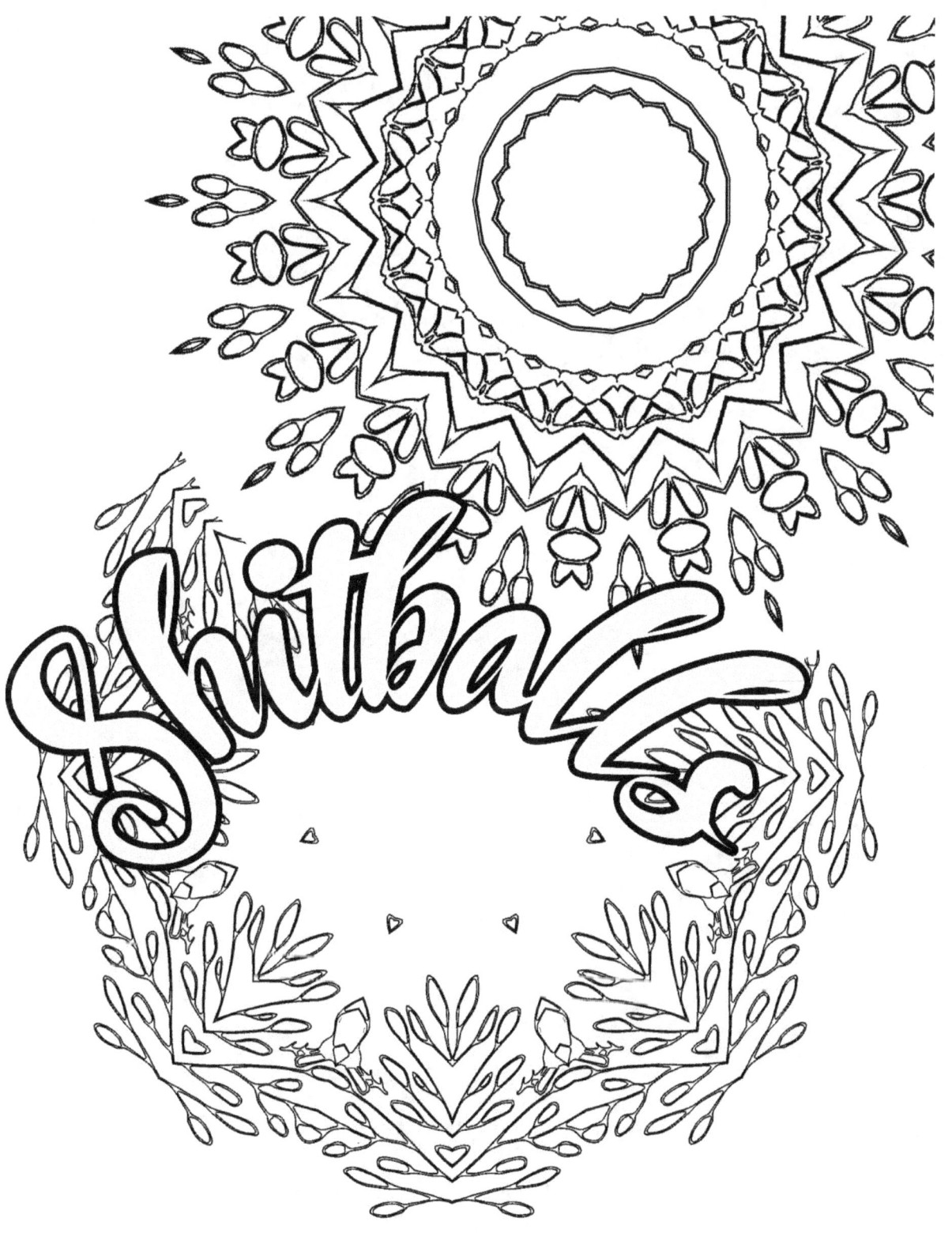

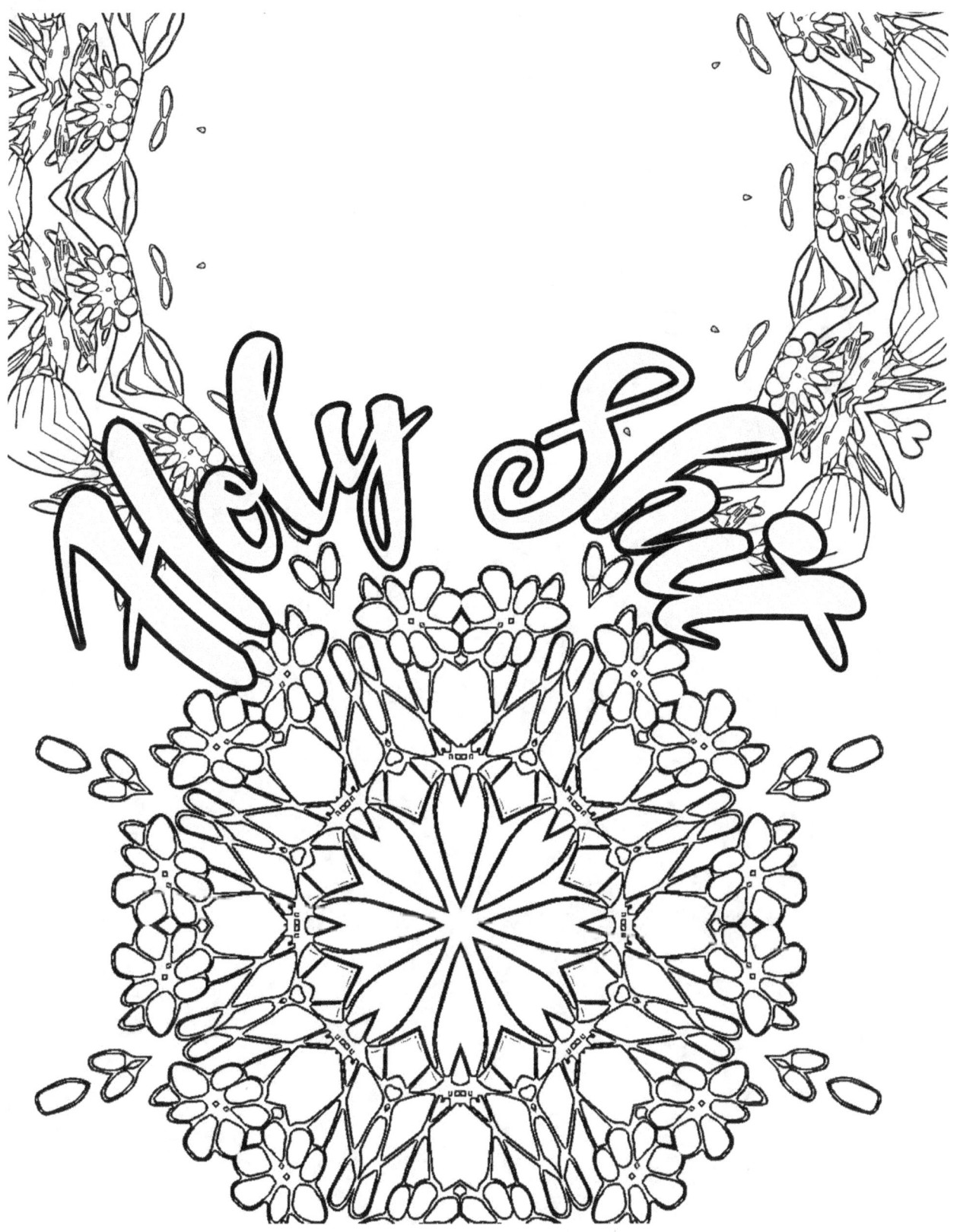

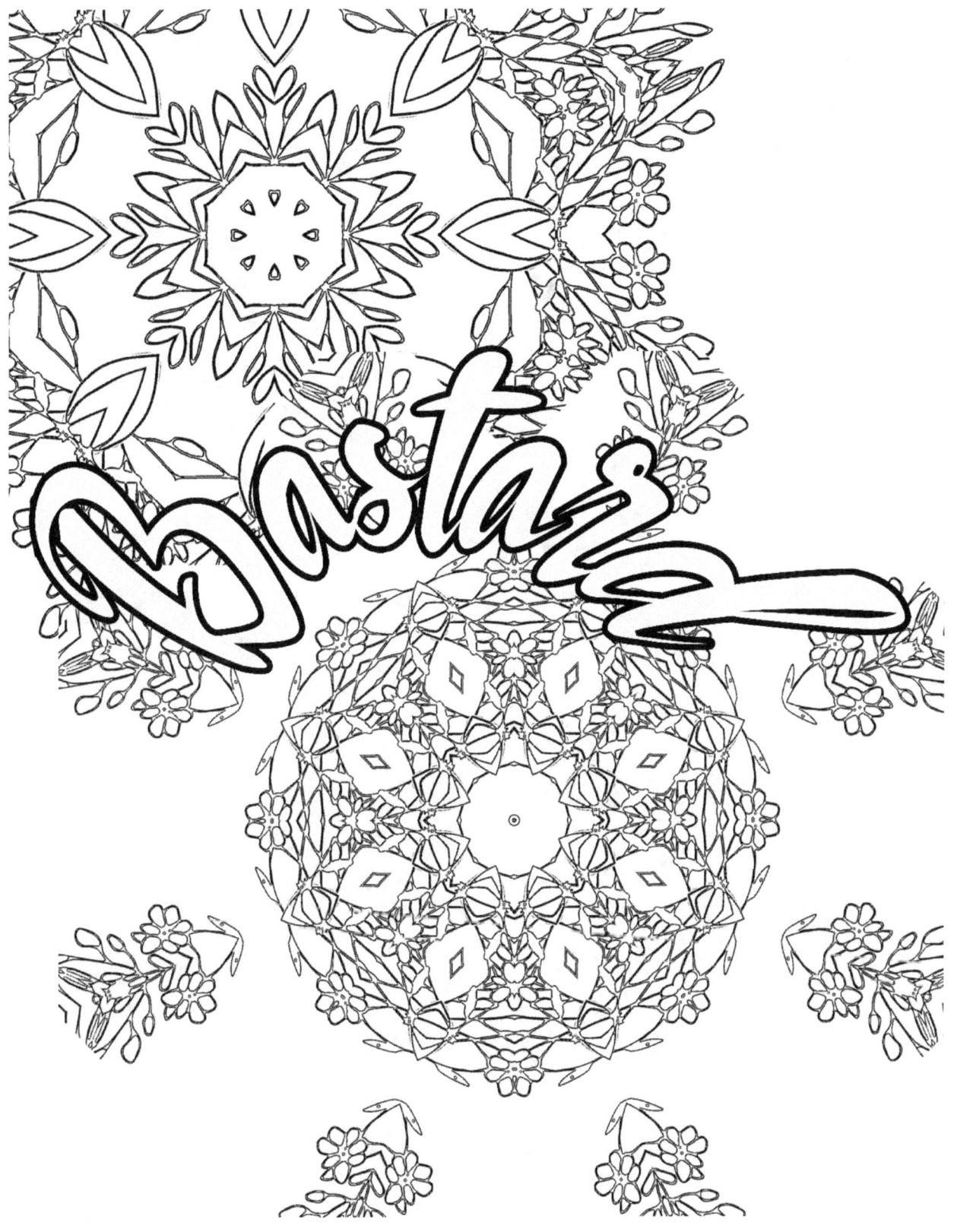

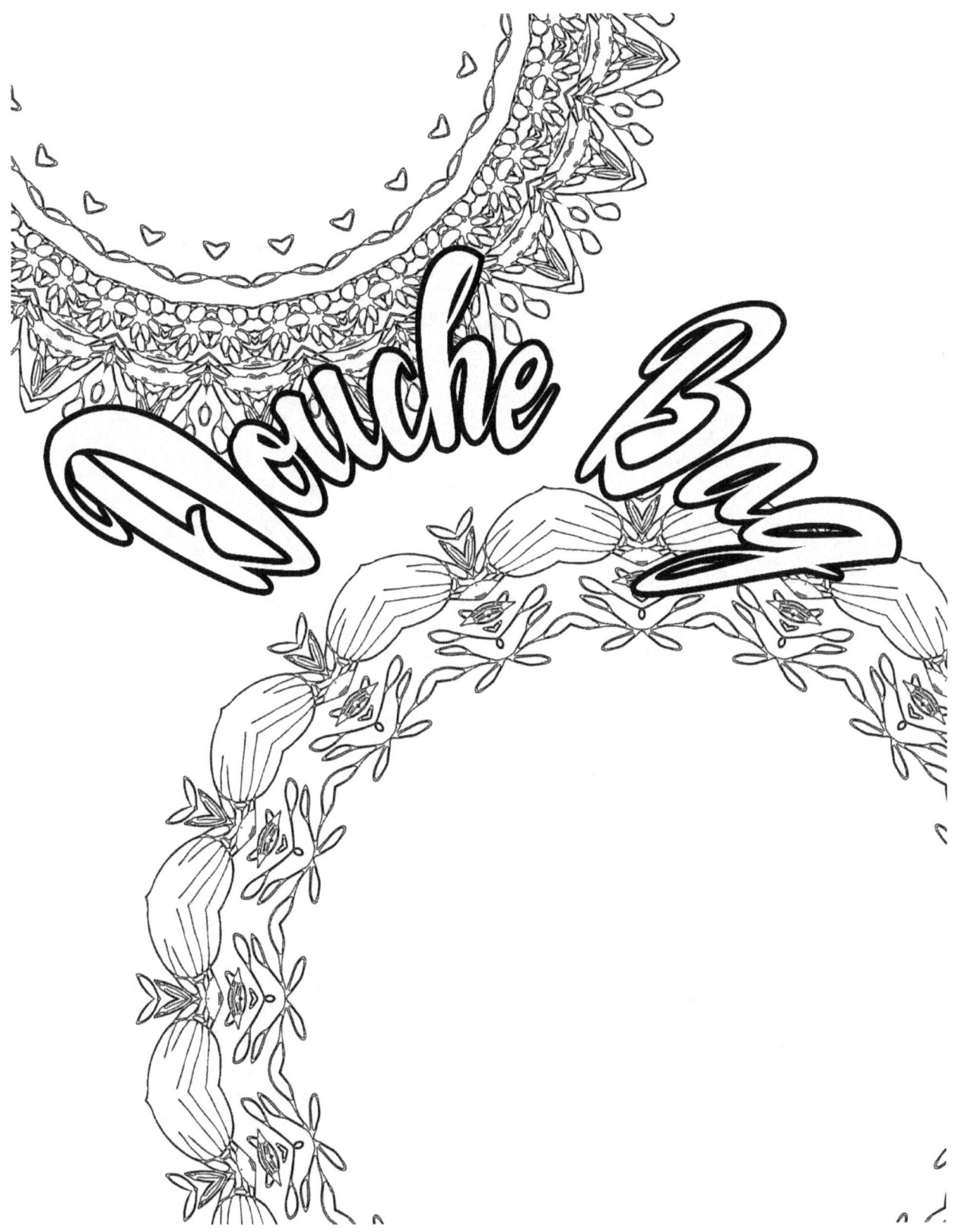

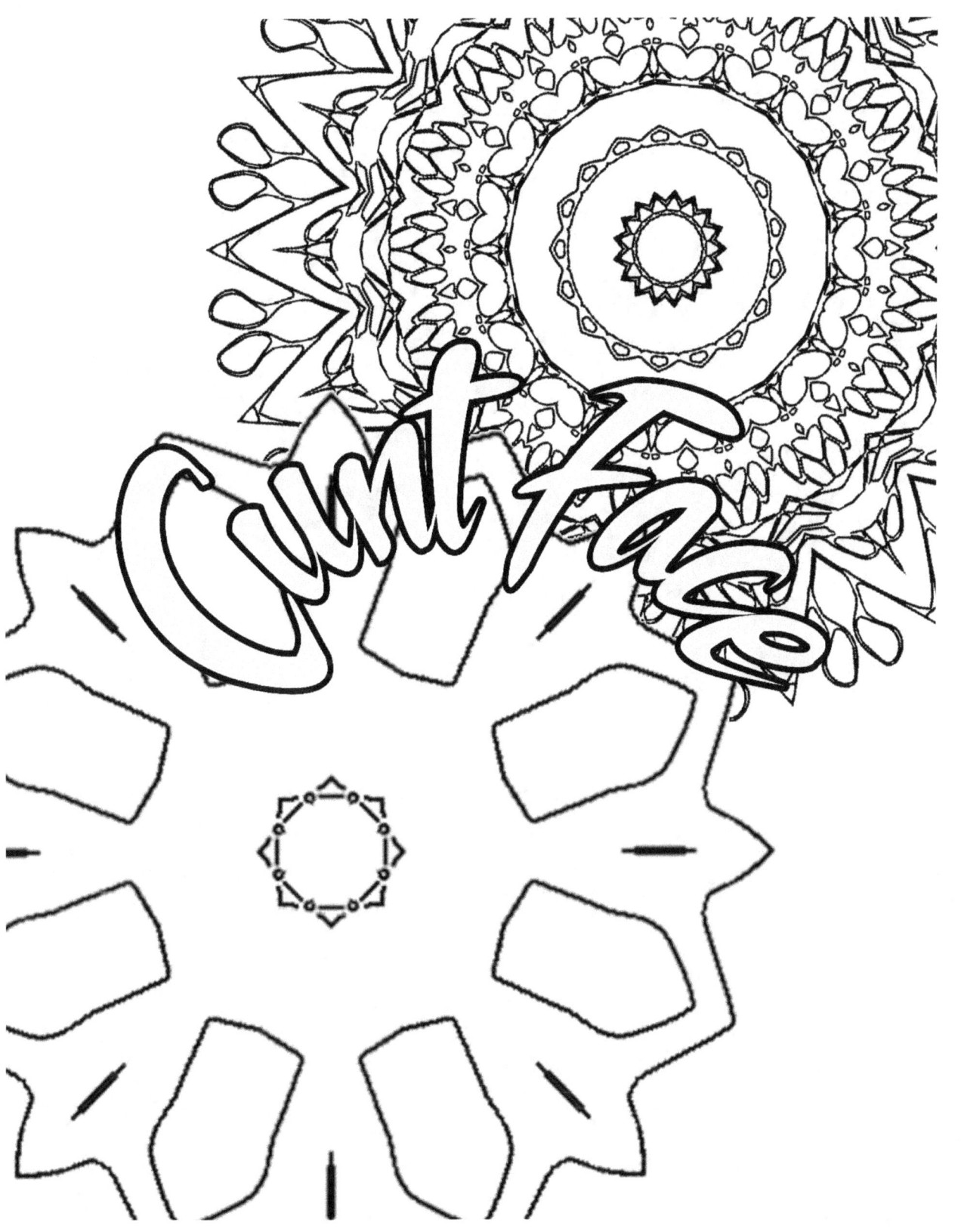

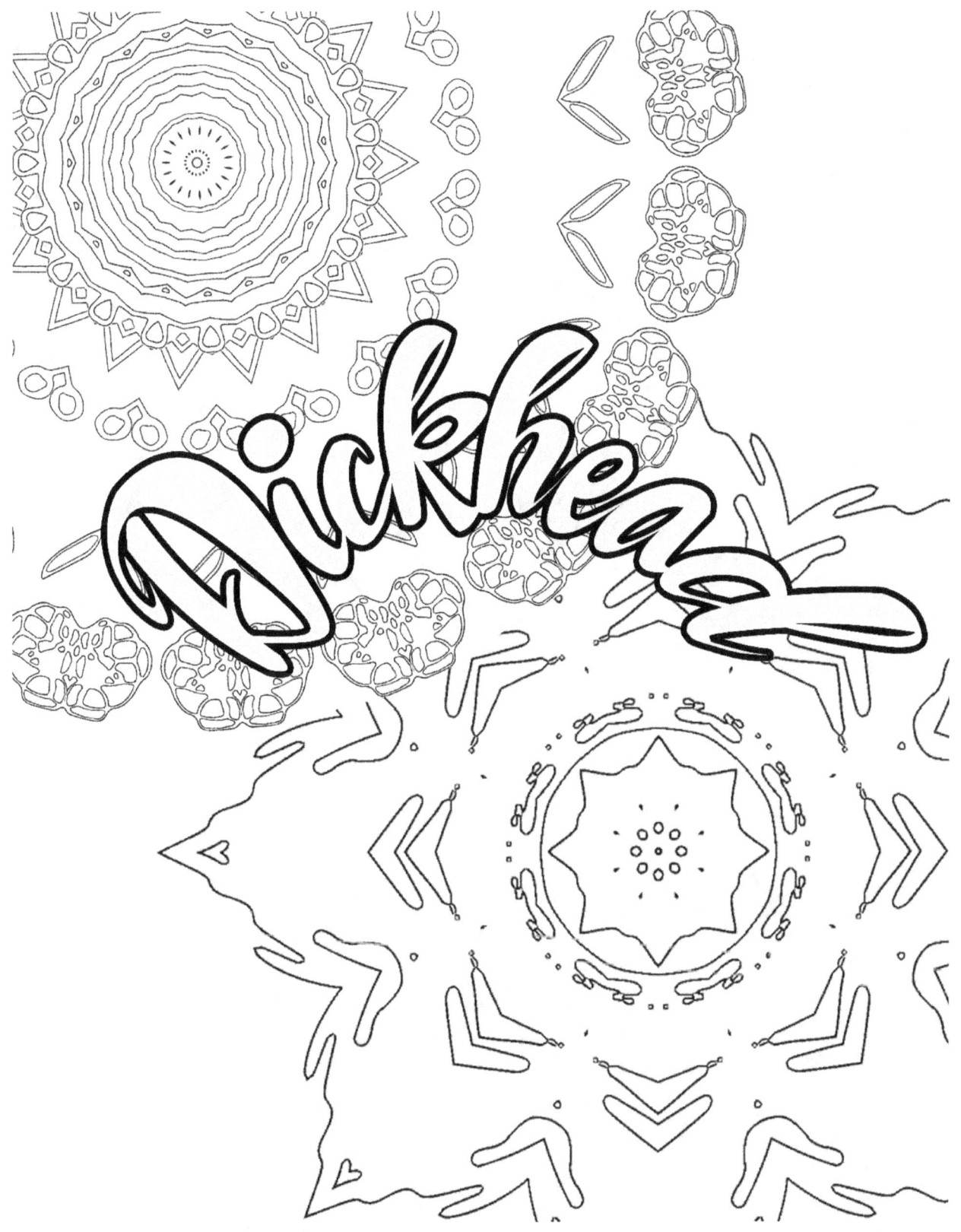

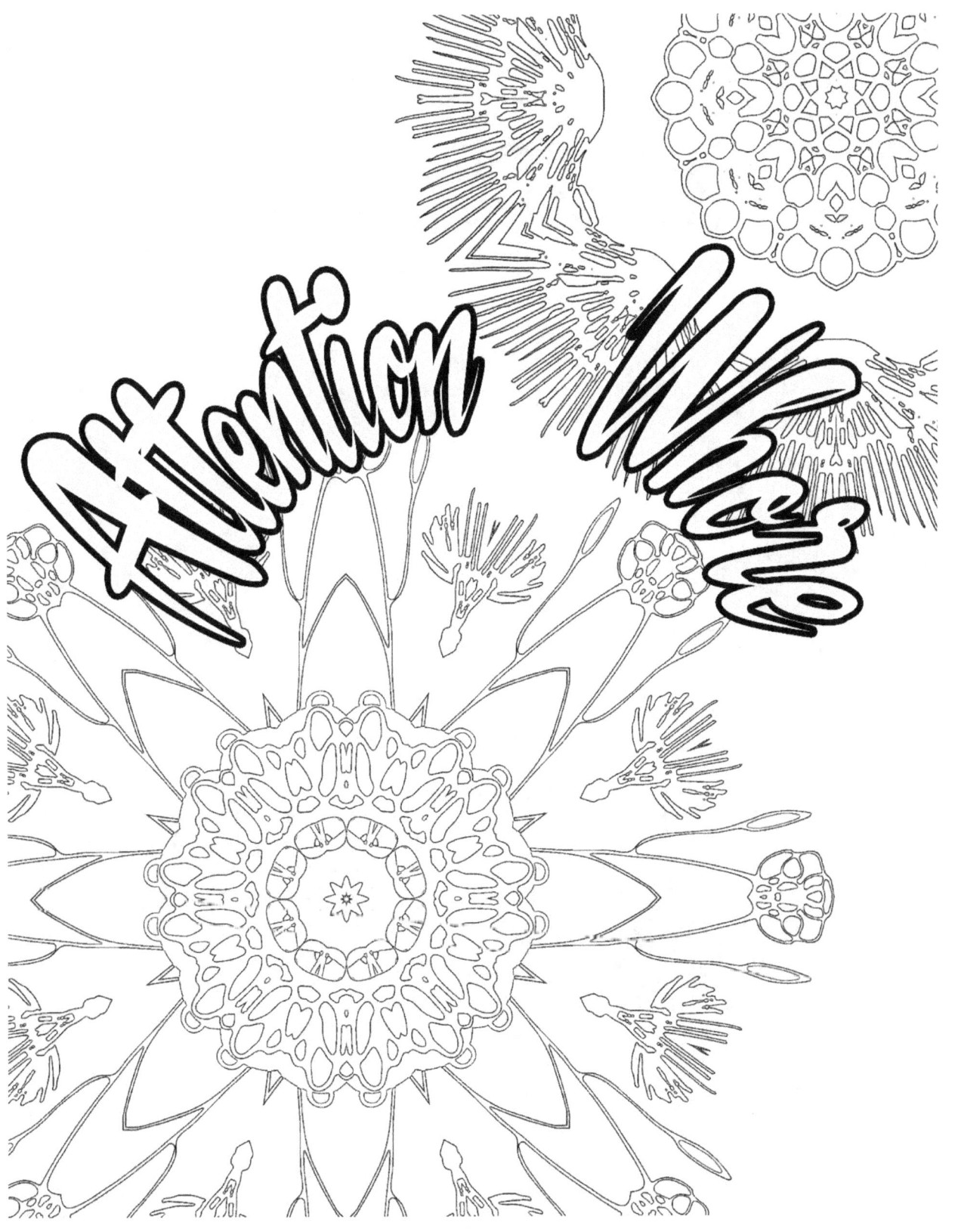

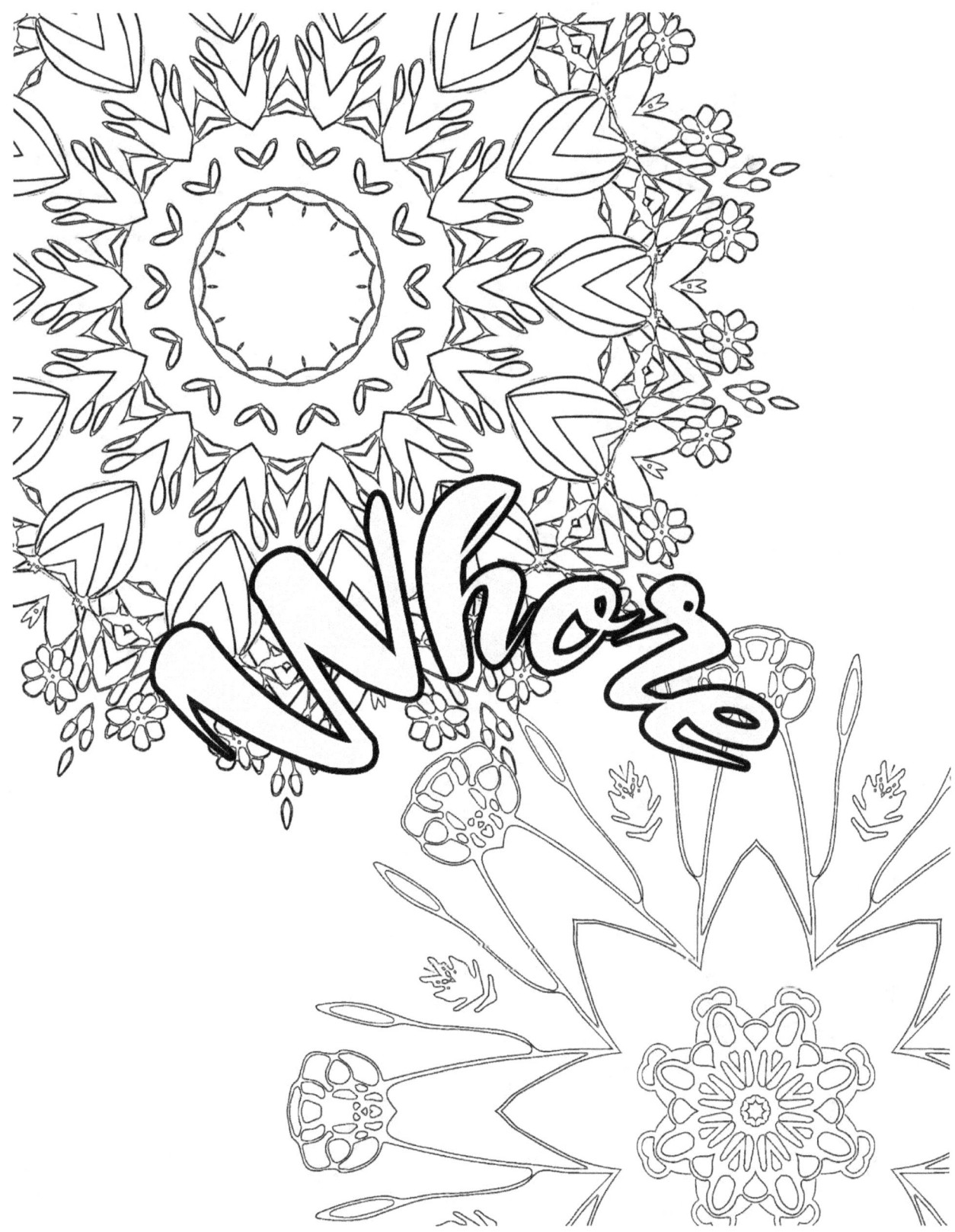

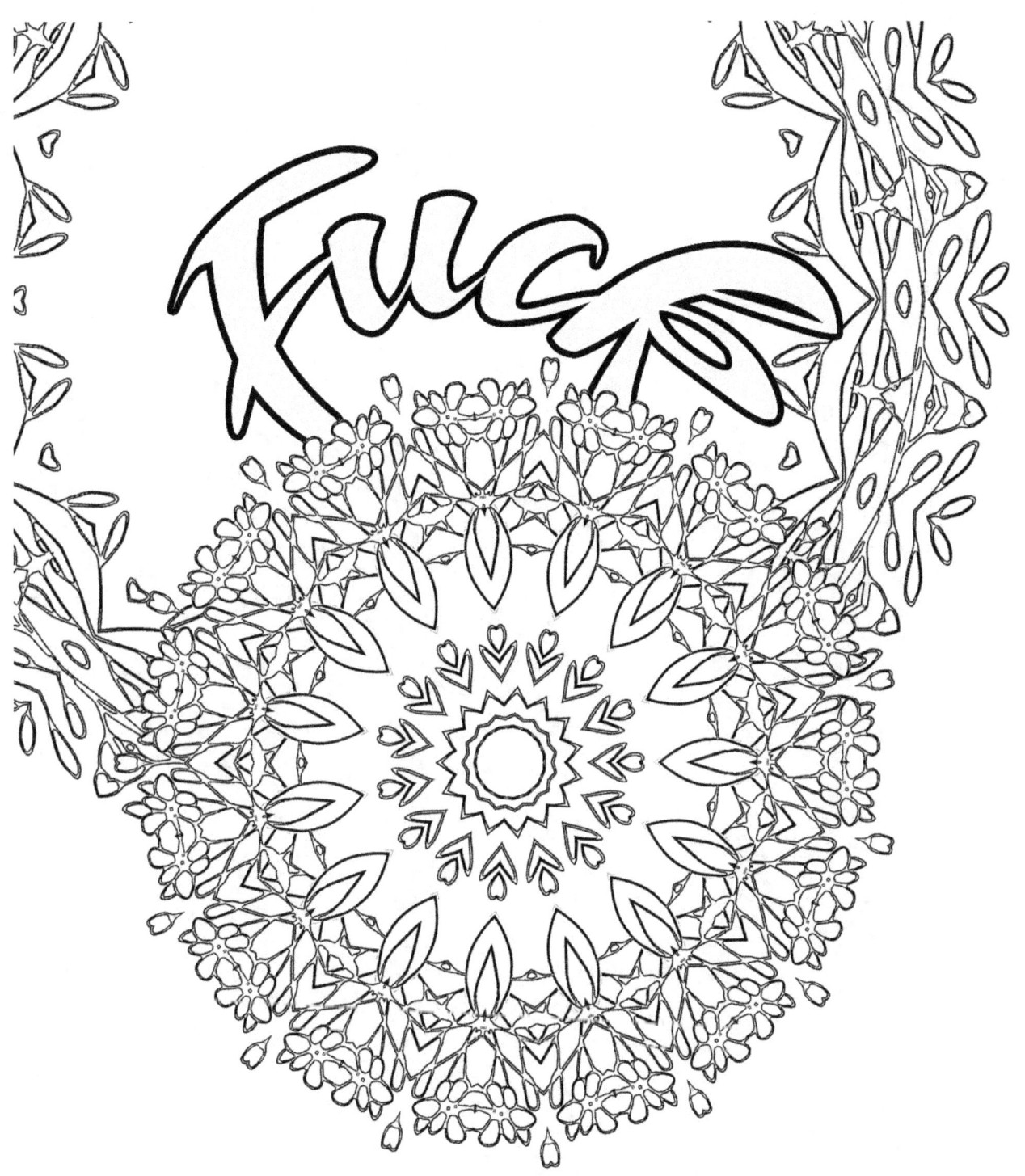

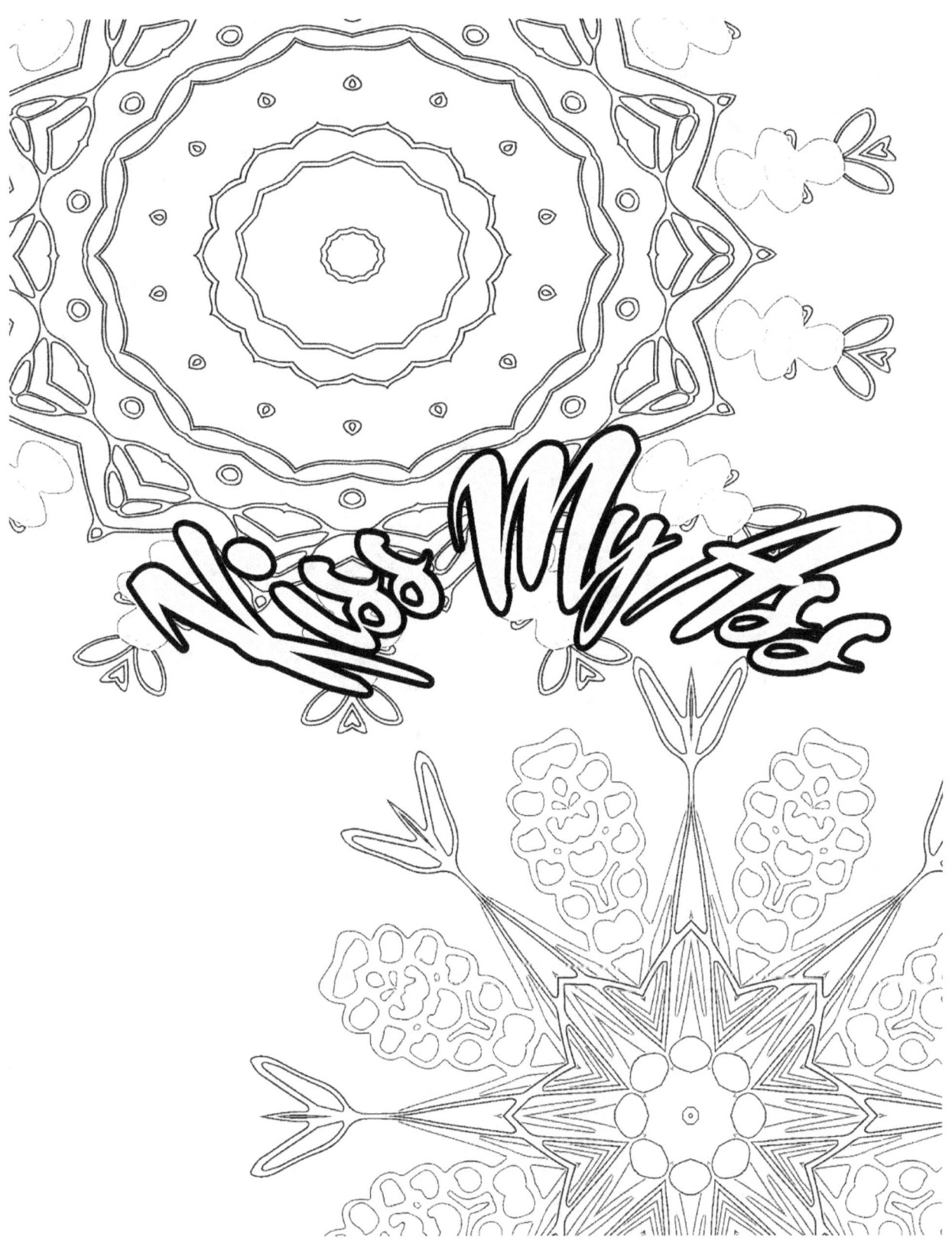

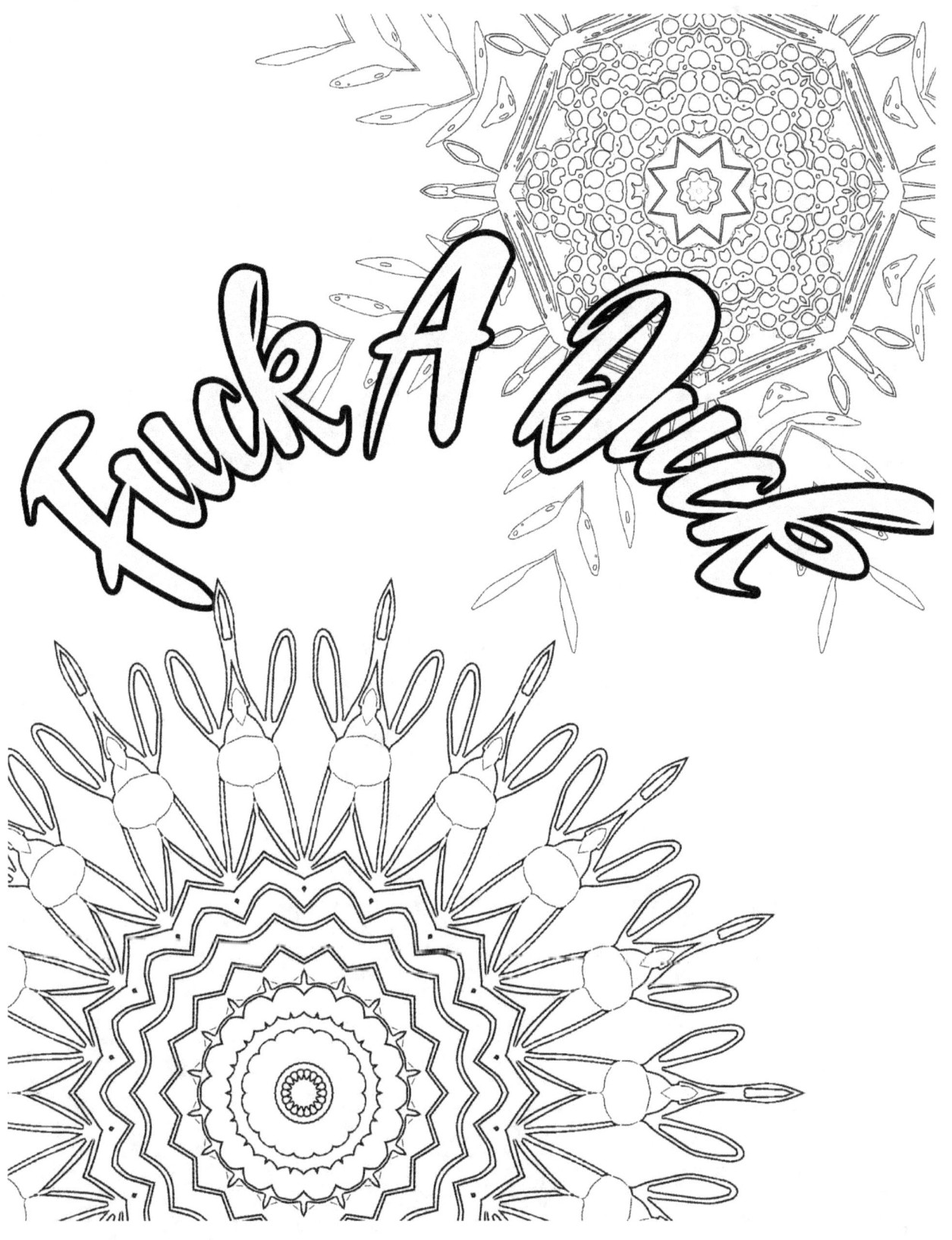

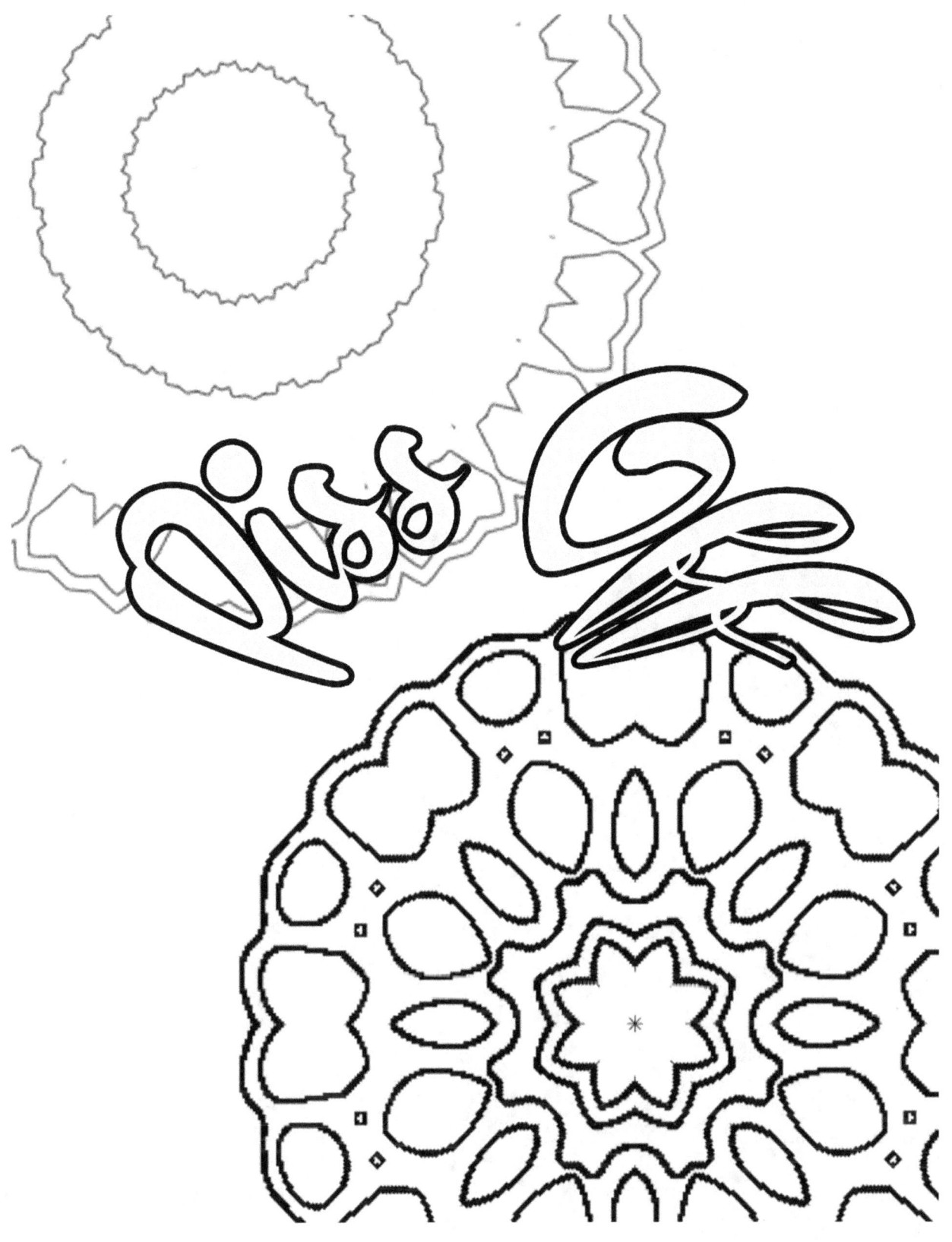

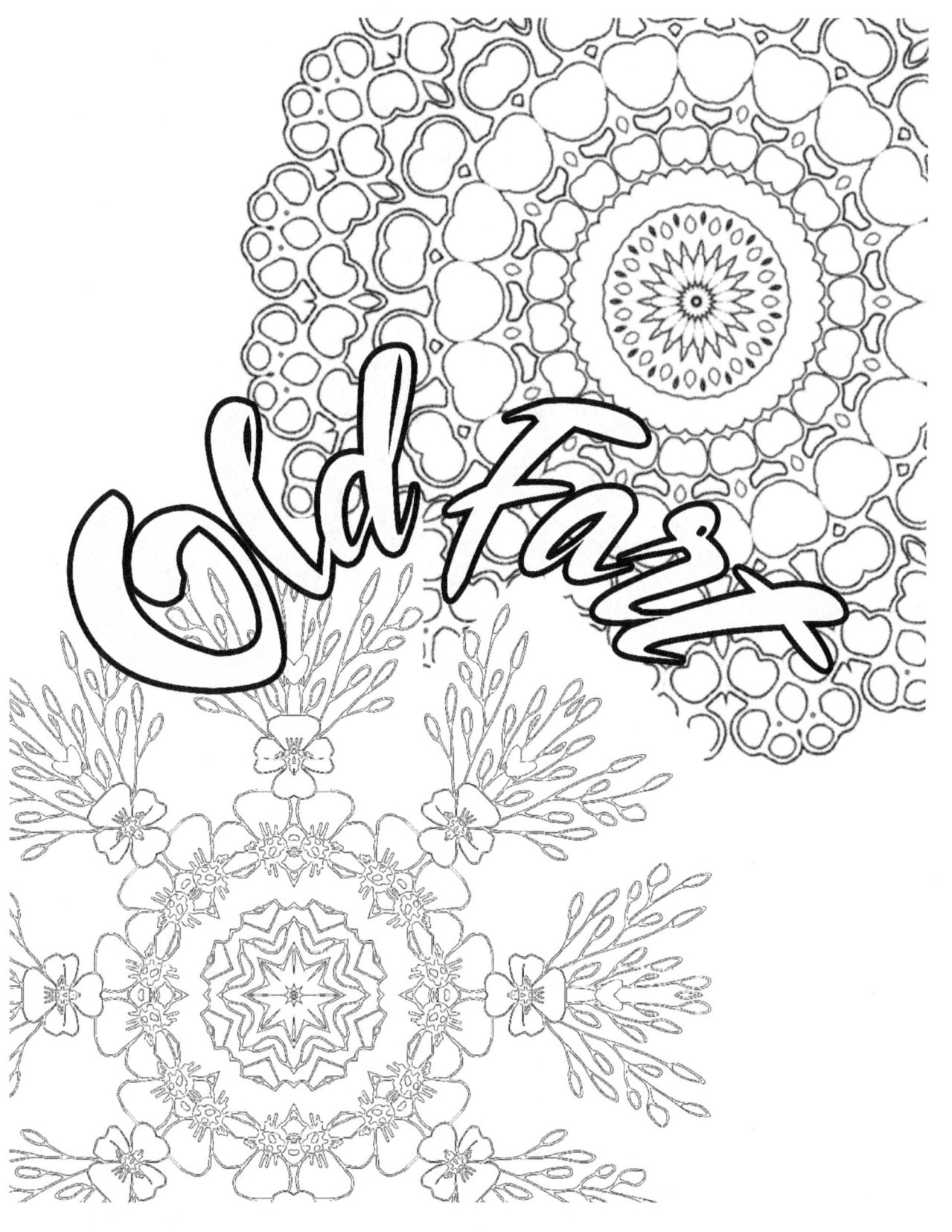

www.ingramcontent.com/pod-product-compliance
Lightning Source LLC
Chambersburg PA
CBHW081125180526
45170CB00008B/3010